THE FLORAL GHOST

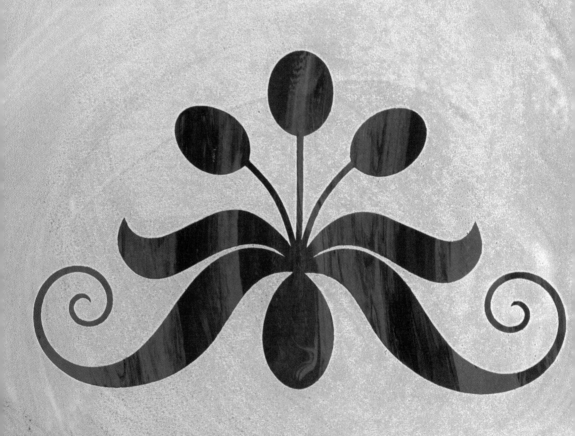

SUSAN ORLEAN

The Floral Ghost

PHILIP TAAFFE

PLANTHOUSE NEW YORK

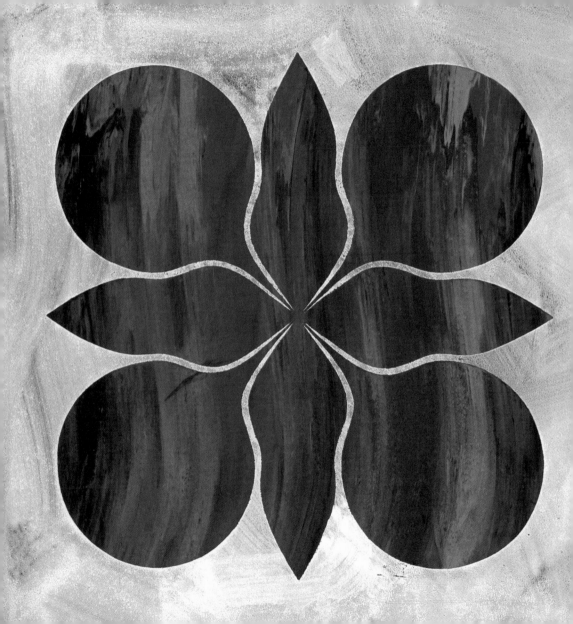

*T*HE FIRST TIME I EVER VISITED the Flower District was late in the afternoon on a hot day so many years ago that even my memory of it has crisped around the edges. This was when Manhattan was a very different place than it is today, when the city still rumbled with manufacturing and trades; when it was still a clutch of sovereign business regions:

the luminous gleam of the Lighting District; the damp and tangy-smelling Meat District; the Notions District, its windows paved with buttons and rick-rack; other districts of clothing, of fish, of dishware. Men with ropey arms and dour expressions moved up and down the streets of those neighborhoods day and night, wheeling carts, delivering a pallet of goods here, picking up a container there, threading between the traffic that barely squeezed by. I was

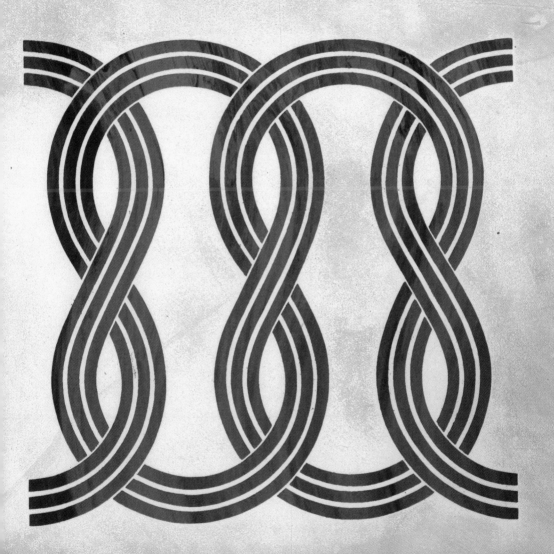

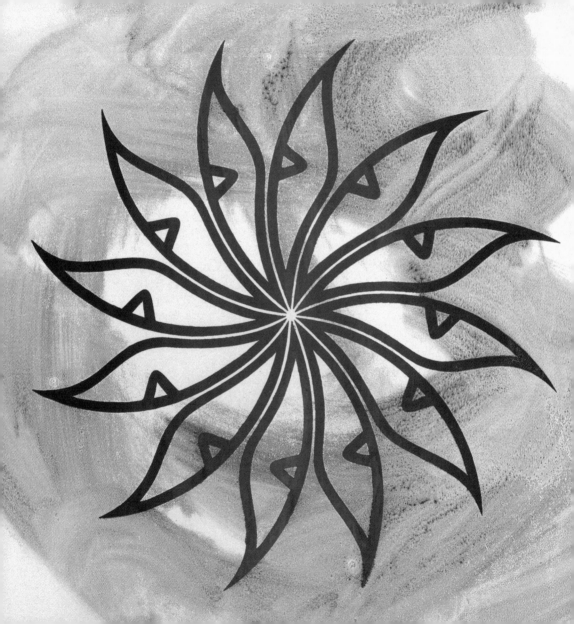

new to the city then—another callow girl
hoping to make something of myself here—
and the place amazed me. Not long after I
had moved to town, a friend invited me to
visit him in his new loft. He said it was in

the middle of the city. "I'm in the Flower District," he explained, and even as I heard the words I couldn't imagine what they meant. A district of flowers? It sounded oxymoronic, coupling commerce with frippery.

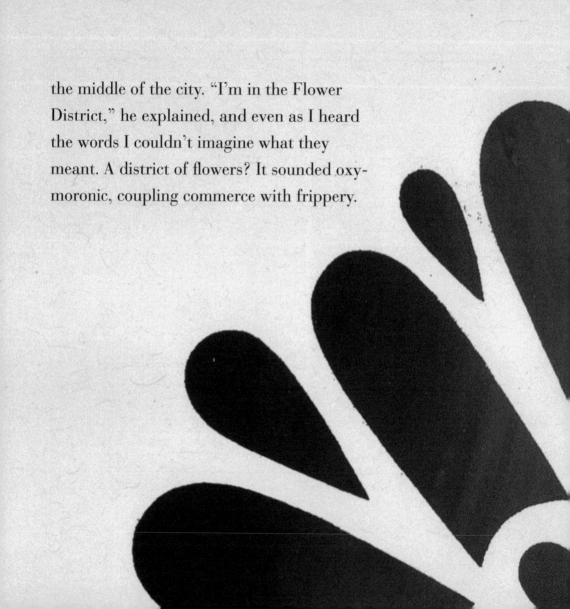

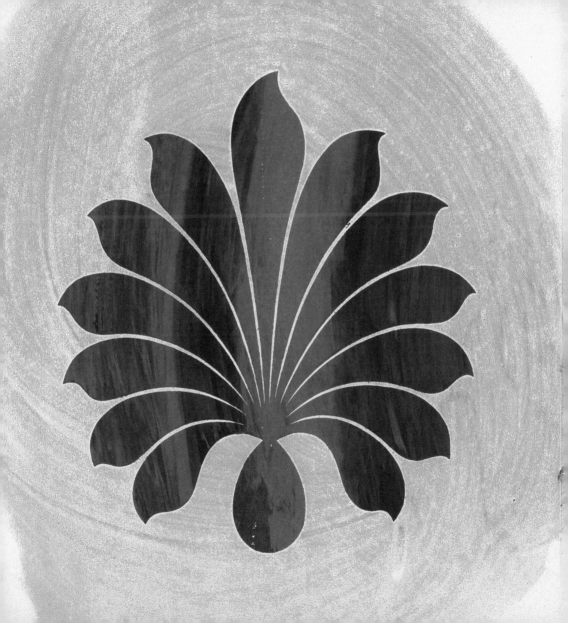

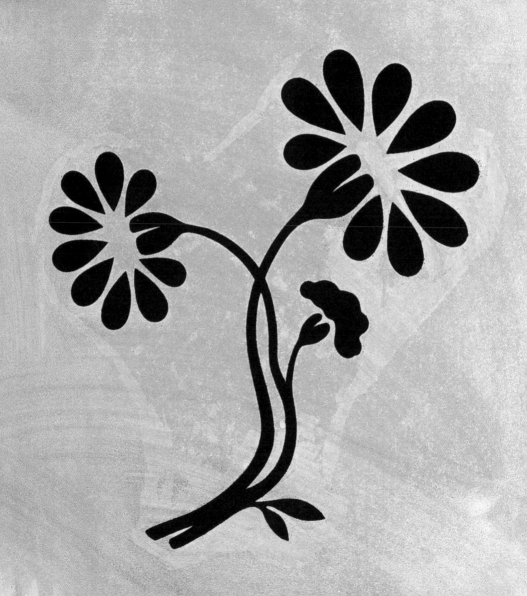

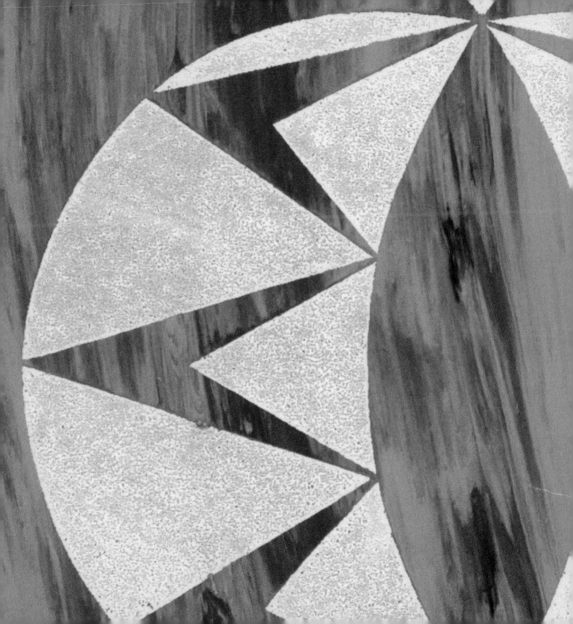

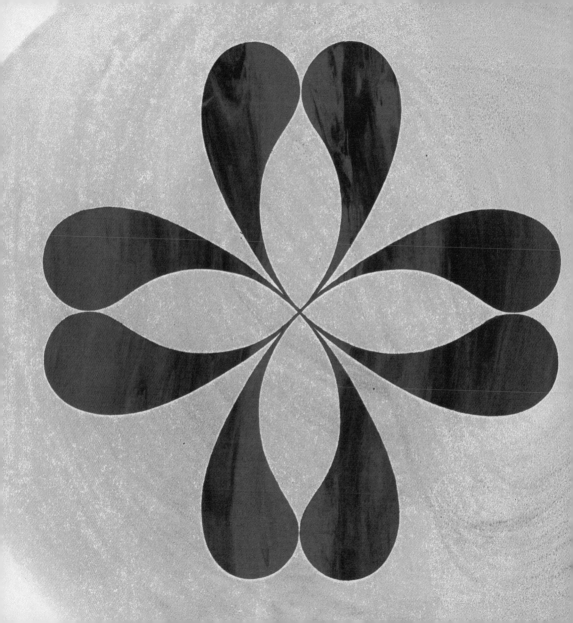

Manhattan didn't seem to me like a place where flowers arrived and left in bulk: Manhattan flowers seemed like they would appear only in artful arrangements in the lobbies of buildings or at the maître d's stands in fancy restaurants. As I got myself ready to go, I thought my friend was making the name of his neighborhood up.

The subway spit me out at 28th Street, and I spun until I could sort out where east was, where north was, and where I needed to go. When I wobbled to a stop, facing in the right direction, I walked headlong into a freestanding forest: A grove of ficus trees, potted and crowded together beside a stand of Dieffenbachia and dwarf Alberta spruce, or maybe a half-dozen Areca palms in big black plastic tubs—of course I don't remember exactly which plants they were anymore, but I do remember the shock of seeing this quiver of

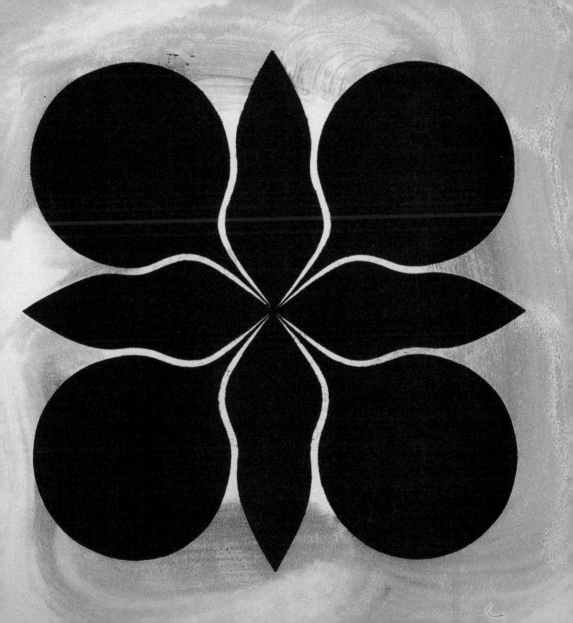

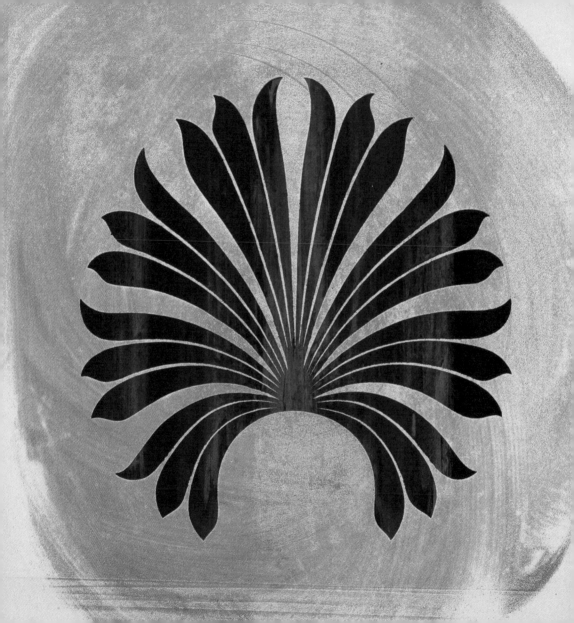

greenery on the gray Manhattan sidewalk, not displayed as decoration but as product, as merchandise. The wet wind that usually sent litter scuttling down the street was instead tossing the fronds of the palms, as if they were on a beach in Mexico. A truck squealed to a stop and dropped its tailgate with a clang; two men, smoking and arguing, rolled by with a cart loaded with ferns.

I elbowed past the sidewalk forest and peered in the storefront, where scores of orchids nodded,

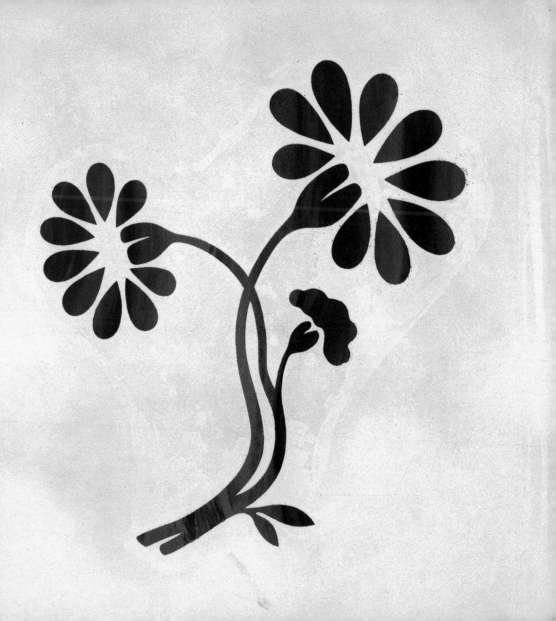

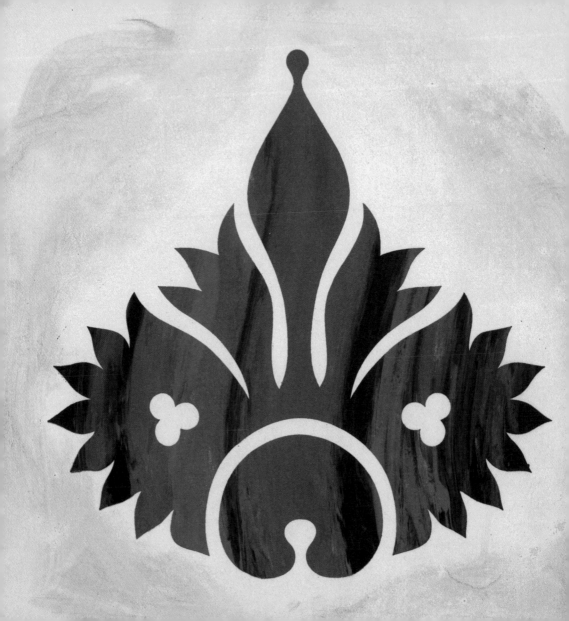

and then into the next storefront, where trays as
big as coffins held mounds of foliage—those good
soldiers, the cheap greenery that is always at the
ready to bloat any bouquet. A panel van with one

wheel hiked up on the sidewalk and its back doors propped open overflowed with pots of cactus and Amaryllis. I continued my walk, dazzled. Sunflowers, rubber-banded in huge bunches; frosty refrigerators full of roses; shelf after shelf of those poor, tortured, curlicued lucky bamboos; hip-high yuccas in faux-Southwestern pots; a window lined with mother-in-law tongues, *Sansevieria*, wagging; every plant and flower and frond in multiples of what looked like millions, shipped here from who-knows-where,

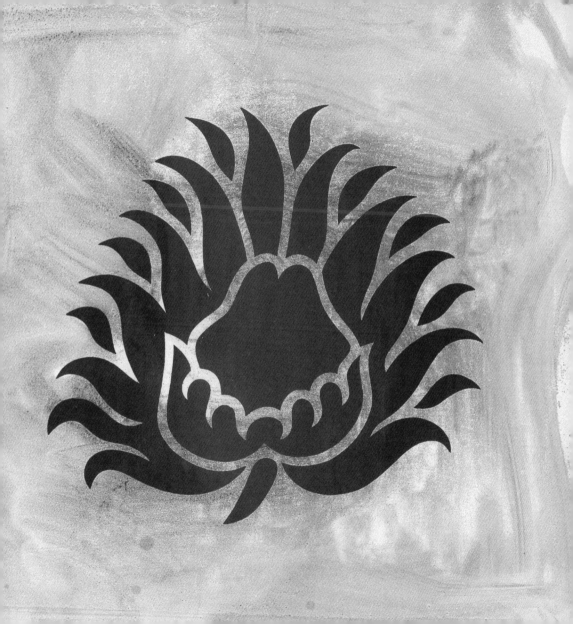

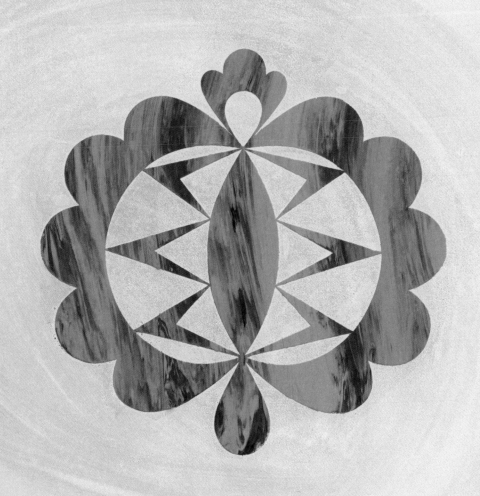

to be sorted out and sent on to somewhere else, being converted en route from a retail unit of a tangible commodity good to a dining-table centerpiece or a wedding corsage or a flower arrangement bought as an apology or a little green something to brighten a dreary corner of a third-floor walk-up with blocked windows.

I once toured a jewelry factory in Thailand, and saw rubies and diamonds piled up as casually as poker chips. At first, I was afraid that seeing

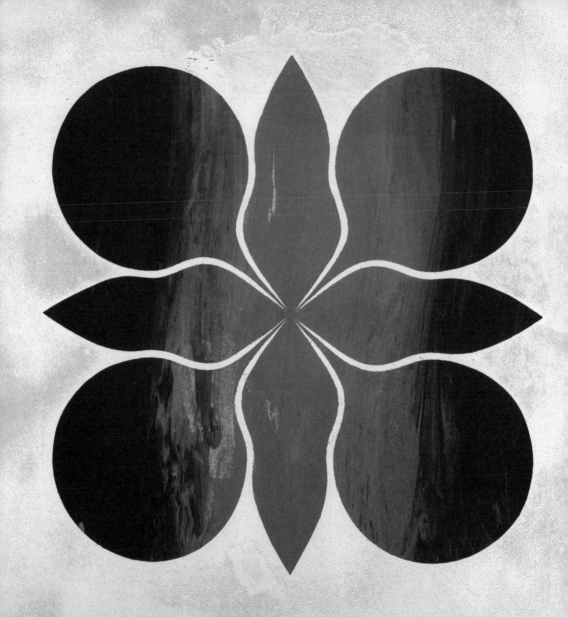

something precious massed up like that, treated so offhandedly, might make it seem ordinary, and that the magic would drain away once the element of scarcity was removed. Instead, I was struck by a different kind of magic: the magic of transformation. The ordinary was

changed right in front of me into the extraordinary; dross
into gold, water into wine, nothing into something, a pile of
shiny stone into a brooch, a ring, something particular and
prized. And here, on this dirty, gummy sidewalk in this
clattering city, crates of merchandise would undergo that

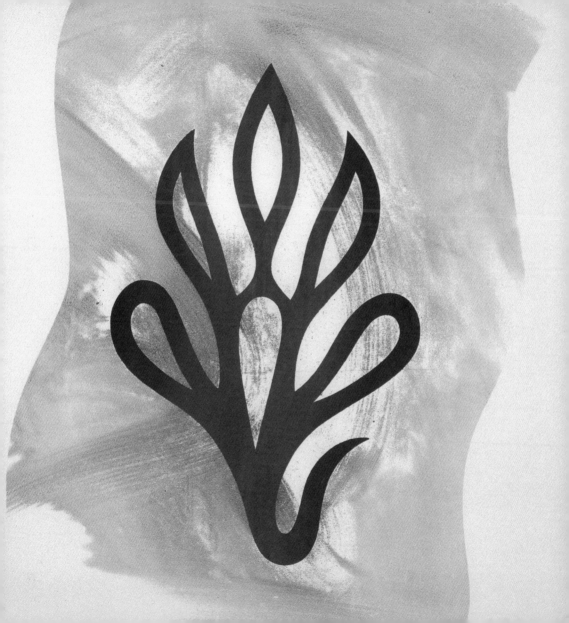

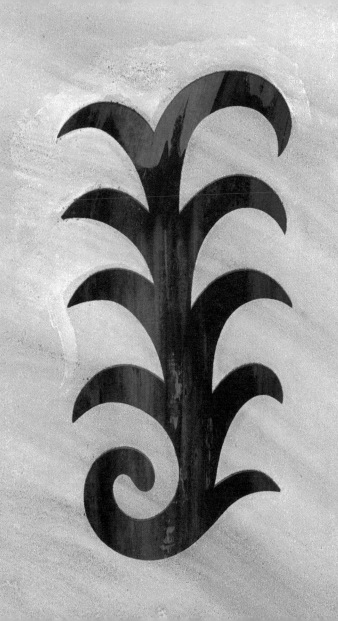

same sort of conversion; they would be made into some-
thing singular and beautiful for someone, and it might
last just a moment, as so many singular and beautiful
things do, but the image of it, flower and leaf, would last.
It was in its way the story of New York itself on that
block, the story of everyone who tumbled into this city—
the undifferentiated lot of us who came here wanting to
make something, and be made into something, that
would become memorable and distinct. The afternoon
light fell to dusk, and I was late for dinner, so I ran down
the block, the green streaming by as I passed.

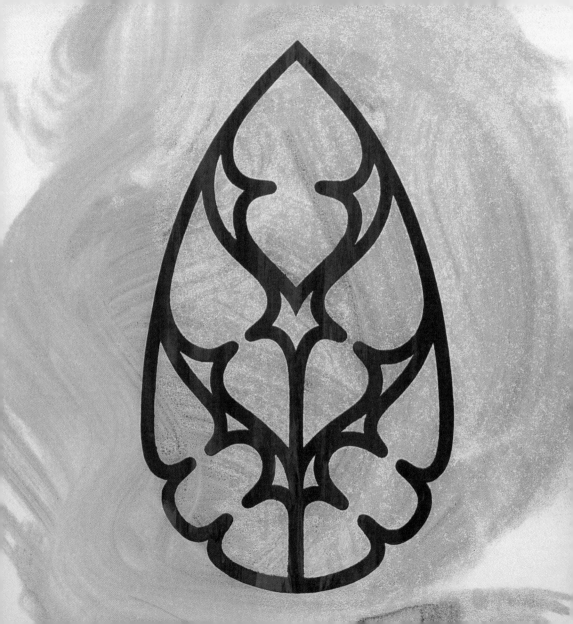

THE FLORAL GHOST

SUSAN ORLEAN PHILIP TAAFFE

PUBLISHED BY PLANTHOUSE, INC. IN 2016

Thank You

May Castleberry, Brad Ewing, Raymond Foye,

Katie Michel, Leslie Miller and Hollis Witherspoon

The typeface is Bauer Bodoni.

Bodoni is a series of serif typefaces first designed

by Giambattista Bodoni (1740-1813) in 1798.

FOR INFORMATION, PLEASE ADDRESS

PLANTHOUSE, 55 WEST 28TH STREET, NEW YORK NY 10001 WWW.PLANTHOUSE.NET

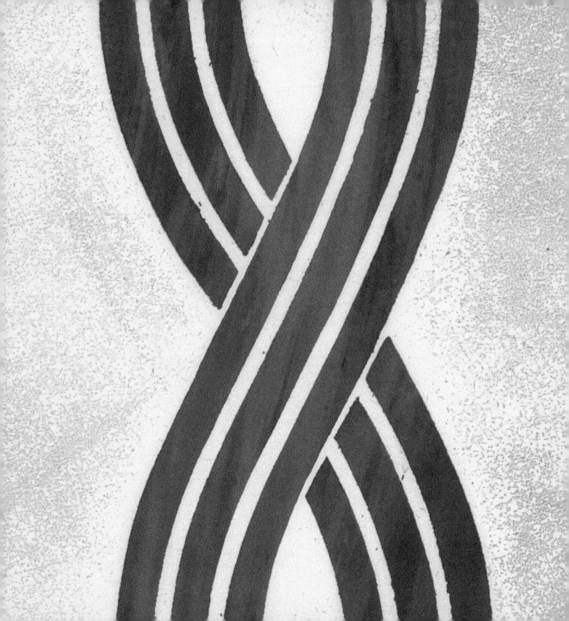